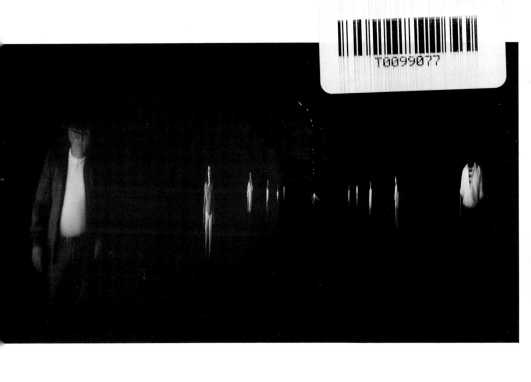
T0099077

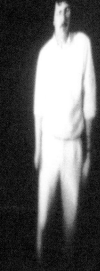

TALL SHIPS

Gary Hill's Projective Installations — NUMBER 2

Text by GEORGE QUASHA AND CHARLES STEIN

STATION HILL ARTS

BARRYTOWN, LTD.

Main text copyright ©1993, 1997 by George Quasha and Charles Stein.

Art interview copyright © 1997 by Gary Hill.

Photos copyright by the artist and/or photographers, noted on acknowledgement page.

All rights reserved. No part of this book may be reproduced or utilized in any form or by any means, electronic or mechanical, including photocopying, recording, or by any information storage and retrieval system, without permission in writing from the publisher.

Published under the Station Hill Arts imprint of Barrytown, Ltd., Barrytown, New York 12507, as a project of The Institute for Publishing Arts, Inc., a not-for-profit, federally tax exempt, educational organization.

Web: www.stationhill.org; e-mail: Publishers@stationhill.org

Distributed in The United States by Consortium Book Sales & Distribution, Inc. 1045 Westgate Drive, Saint Paul, MN 55114-1065.

Library of Congress Cataloging-in-Publication Data

Quasha, George, 1942-
 Tall ships / text by George Quasha and Charles Stein.
 p. cm. – (Gary Hill's projective installations ; no. 2)
 ISBN 1-886449-54-6 (alk. paper)
 1. Hill, Gary, 1951- Tall ships. 2. Hill, Gary, 1951-
 Criticism and interpretation. I. Hill, Gary. II. Stein, Charles,
 1944- . III. Title. IV Series : Quasha, George, 1942- Gary
 Hill's projective installations ; no. 2.
 N6537.H533A77 1997
 709'.2—dc21 97-12548
 CIP

Printed in the United States of America

Contents

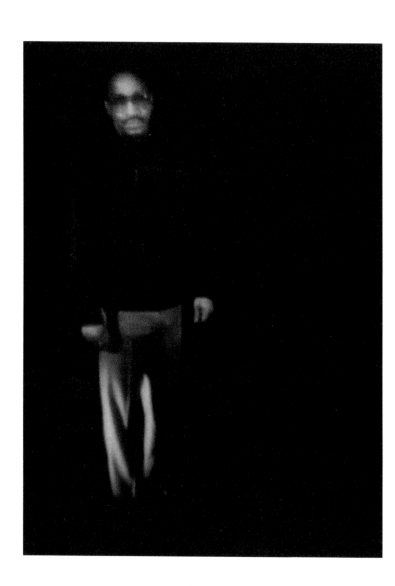

Preface

This book is the second in our series on Gary Hill's projective video-installations, following upon *Gary Hill: Hand Heard/liminal objects*. The installation TALL SHIPS, commissioned by Jan Hoet for Documenta IX of 1992, is one of the artist's relatively early uses of video projection as installation, following by two years BEACON *(Two Versions of the Imaginary)*, arguably the first close kin of TALL SHIPS. It predates by four years the Paris installation of *Hand Heard* at the Galerie des Archives, for which, in collaboration with the show's curator, Fabienne Leclerc, we inaugurated the present series of books. Our text here, "Tall Acts of Seeing," appeared in an earlier form in 1993, commissioned by Dorine Mignot for the Stedelijk Museum retrospective in Amsterdam.

We speak of these installations as "projective," first of all, because they involve recorded video that is projected onto walls or other surfaces. This technical distinction applies to a significant number of Gary Hill's works. The actual beginning is 1987 with *Mediarite* and its later manifestations as *DIG,* both involving multiple projection and viewing devices. Then there is a beginning in 1990, as mentioned, with BEACON..., in which full-scale human figures enliven a neutral surface, so that the space itself, the actual room, becomes the "projective" medium. In this same year, *And Sat Down Beside Her* involves projection of both live figures and text onto discrete objects, in effect animating, as well as textualizing, the surfaces. The next two years followed with *I Believe It Is an Image in Light of the Other,* TALL SHIPS, CUT PIPE and *Some Times Things.* Of course this particular technical orientation is hardly the only one Gary Hill engages—indeed, arguably not even the principal one, since an equal number of important works in the

same period do not foreground projection so much as develop ways of working that originated more than a decade earlier. But the discoveries at the heart of this projective work have gained momentum in more recent works: *Learning Curve* and *Learning Curve (Still Point)* (1993); *Dervish, Remarks on Color* and *Circular Breathing* (1994); *Hand Heard* (1995-96); and *Viewer, Standing Apart* and *Reflex Chamber* (1996).

Viewer and *Standing Apart,* along with *Facing Faces,* are central to our discussion in the third book in this series, *Viewer: Gary Hill's Projective Installations,* No.3. And we have written about *Cut Pipe* in a piece that appeared in *Public 13: Touch in Contemporary Art* (Toronto: 1996), bearing the formidable title, *"Cut to the Radical of Orientation:* Twin Notes On *being in touch in Gary Hill's [Videosomatic] Installation,* Cut Pipe.*"* In all of these pieces our treatment of the "projective," whether under that or another name, is hardly limited to its technical sense. Certainly the issue of technique is quite important, and no doubt there will be the inevitable discussions of who used what technique when (since a number of artists have recently been using video projection). Priority is not for us a core issue, although we have tried to contribute indirectly to the clarification of this matter. (See Note 5 below and the brief description of Gary Hill's spontaneous personal discovery of video projection many years ago.)

What interests us far more is the way these projective works function as meditations on—or, perhaps, "meditative spaces" for—the experience of projection itself, in all its senses. Projection-related words have held a central position in many disciplines, including, for instance, psychology, mathematics, topography, philosophy and poetics. (Certainly, in regard to the latter, poetics took a new direction with Charles Olson's "Projective Verse" of 1950, an essay whose impact was comparable to the work of others from the seminal context of Black Mountain College, such as John Cage, Merce

Cunningham and Robert Rauschenberg.) We see the projective as a major issue with many resonances, but our approach is to focus on the actual experience of certain works—to register the resonance directly. Our habit of inventing and reinventing words to serve our own ends is an attempt to open a space where that resonance can happen—for us, and hopefully for the reader too. Our wish is to explore and extend—to "read out"—certain possibilities at the heart of Gary Hill's work and the projective itself. In fact we do not view our texts as "art criticism" as such, but as dialogical writing directly engaged with specific work and its fundamental concerns.

To put this in context, we should mention that we have known Gary Hill since the late '70s. The relationship is collaborative and dialogical. "Dialogue" for us is a charged word, meaning something more than intelligent conversation. In talking with each other on matters of common concern, it is often the case that thoughts and insights arise that, apart from this occasion, would find no other way of becoming articulated. What gets said does not really originate within a certain participant in isolation, but arises instead in a space "between" the interlocutors. We regard this state of intellectual and spiritual emergence as intrinsically valuable, and we sometimes refer to it as *the dialogical* or, more specially, *DiaLogos*. Its underlying power and possibility derive from a precarious state we call *liminality* (a notion developed in the other two books in this series). It is our view that much in Gary Hill's work comes from, reflects upon, searches within, and enacts such liminal states. And what they come down to, in the terms of this essay, is "being on the verge."

Accordingly, our dialogical participation—like that of any tuned-in viewer—is an instance of the work's own *further life:* an extension of the creative energy and interest that the work itself actually projects through its own instance. One's accurate

experience and consequent reflection is an objective manifestation of that instance, that life. This view of course is a presumption, but one that is grounded, we believe, in the nature of the work—not only what it is about but what it is. Gary Hill's work induces unique, often disorienting experiences in those who genuinely participate. These are experiences that each viewer must resolve by some manner of *further* inner creative work—even if this takes form in no more public ways than one's private dreams or dialogues with others. The individual viewer strikes a level of equality, of equilibration with the artist. So the accuracy of accurate viewing, to paraphrase the poet Wallace Stevens, enjoys an accuracy with respect to the structure of the work, which itself is a vision of the real

GEORGE QUASHA AND CHARLES STEIN
MAY 1997, BARRYTOWN, NEW YORK

*16-channel video installation (NTSC, black-and-white, silent) with 16 modified monitors, 16 projection lenses, computer-controlled laserdisc players and switching runner mats for interactive triggering.**

Down a completely dark, ninety-foot long corridor-like space, sixteen black-and-white images of people, varying in ethnic origin, age and gender, are projected directly onto the walls. No border of light defines the frame of the images: only the figures themselves give off light into space. The last projection is on the back wall, at the end of the corridor. From standing or seated positions ranging from one to two feet high, the figures are first seen in the distance at approximately eye level. As the viewer walks through the space, electronic switches are triggered, and the figures walk forward until they are approximately life-size. They remain in the foreground, wavering slightly, until the viewer leaves the immediate area. Since all the projections are independently interactive, any number of figures can be in the distance, walking toward or away from a viewer, or standing in the foreground, depending on the number of viewers in the space.

*See Note 1 to "Tall Acts of Seeing" below for further details of the two versions (12- and 16-channel), the respective disposition of personnel, and the first exhibition venues.

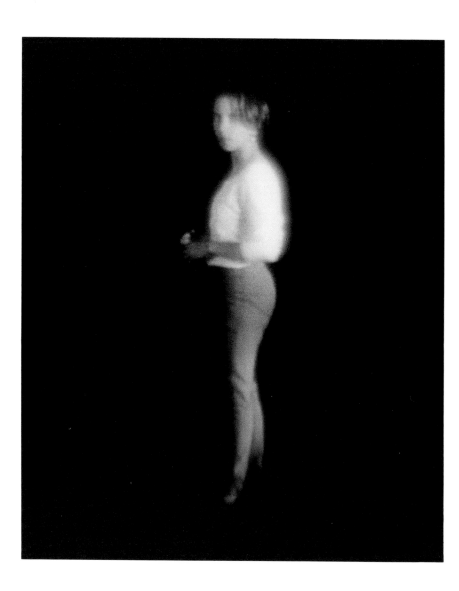

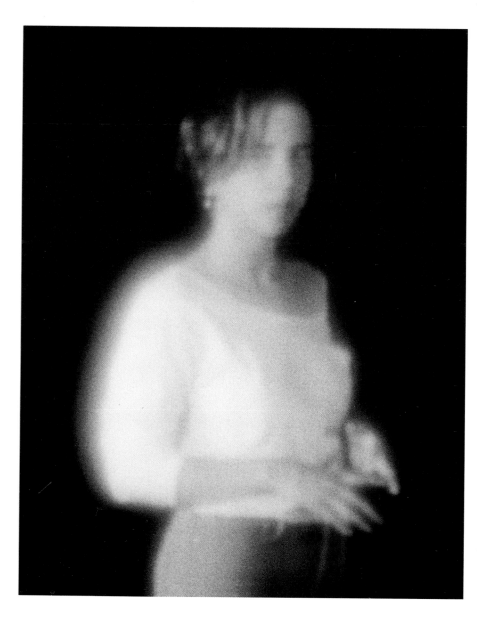

TALL ACTS OF SEEING

It has been reported that, at the 1993 installation of Gary Hill's TALL SHIPS at the Whitney Biennial, there was a sighting: Woody Allen was visiting the exhibition. Alas, despite his companion's insistence that this is a wonderful piece and really should be experienced, Woody Allen refused to enter the unlit enclosed hall: He's afraid of the dark.

Maybe it's just as well he didn't go in, because he's likely to have encountered one or more species of the things that go bump in the night.

What kind of things? Let's think about this according to the special "dia-logic" of the work itself—what takes place, that is, between us.

The piece is a kind of cave or underground passage—very dark, so that when you first enter you may well go bump against someone already in there. From an unseen source, black-and-white images of twelve different people are projected all along the walls on both sides of the corridor with a single image about sixty feet down at the end of the hall[1]. When you approach one of these images, say, of a seated woman, and stand there before her, she responds to your presence by getting up and walking straight up to you, there to remain, "life-size," for a longish period, simply standing and sort of looking at you. If you leave, she turns around and goes back to the original spot and sits down; on rare occasions, she may leave before you do; and if you leave and then decide

to go right back, the person walking away will turn around and come back to resume standing, extending this meeting even further. That's the piece. So what's there to be afraid of?

Continuing our thinking according to dialogical indications: It *is* pretty dark in there, and you're wandering around with strangers you can't see, though sometimes you hear them talking, or at least making what can only be called *human noises*, and after a while you can start to see the shapes of the people passing before the images, their faces indirectly catching some of the light from the projections. Except for brushing against a shoulder or two, there's not much contact with others. Mainly it's just you and those people who get up for you and come forward as if to make contact. Only there's no contact.

Mostly you're alone—alone with yourself and the projection. No sound at all but the ambient sound, and when the latter is people talking, it feels somehow inappropriate or even interruptive, as though they're uncomfortable and need to fill the space with something familiar. That usually doesn't last long because these people tend to get in and out quickly, as though they had stumbled into the wrong Disneyland attraction that didn't attract. Then you're alone again. Perhaps a few of the slower moving, quieter entities are still cruising the room, light glancing from their faces like white sails in the moonlight. And in front of you someone is getting up and walking toward you, coming to meet you. What now?

What Mirrors?

This is the space in which it all happens.

Evidently it's different for everyone. How one relates to standing in front of a total stranger, in a rather intimate moment of eye-to-eye contact (although the soft focus of

the projection keeps the gaze this side of penetrating), determines the quality of the first order of one's response to the piece. The moment can be unsettling.

Though it's dark you might *feel seen*, or at least *sensed*, perhaps even a bit naked or stripped of defenses. After all it's pointless to speak or gesture, although you might unintentionally make one of those messageless gestures linguists call "phatic," designed to forestall contact when in the situation of *going to meet*. Only there's no meeting. Right up to the point when you just might speak, but no speaking. For some, this could be a kind of freedom: I can look without having to speak or make contact—free of a certain anxiety. For others, it might reinforce the sense of isolation in the going-to-meet/never-really-meeting of social situations. At the very least you become aware of what the person in front of you is going through: How that person is handling the situation of having to just stand there in front of someone unseen yet intently looking on (How would *you* handle it?). It can be funny, fascinating, mesmerizing, painful. It can bring some stuff up in you. Something frightening, something unwanted. You might not want to stick around or you might prefer to start intellectualizing about interactive video, lest something go bump. Maybe Woody Allen had a point. And what's it got to do with art?

Before we think more deeply about this, let's consider how actual people have responded. We'll defer our own various responses, with one particularly vivid exception: Namely, one couldn't help intermittently fantasizing that these colorless, even wraith-like, yet curiously attractive figures were, as one imagines them, the recently dead, returning for some warmth of last contact with the living—as in the *bardo* or the Homeric Underworld (when Odysseus, descending in search of prophecy, is approached by the spirits of lost friends and family).

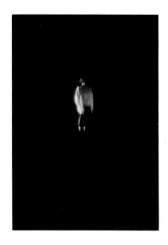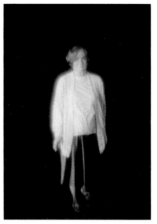

And here is a rather poignant account by Barbara Leon of her visit to the Whitney installation[2]:

> Viewing the first two people I couldn't shake the feeling that the piece was completely interactional, that they were actually responding to me! I felt that *void* that comes up when you interact with someone new, that vertigo of unrequested spontaneity. I had the apprehension that another person would know me before I could know that person. Even though the characters weren't actually waiting for your input, you felt they were responding to your actual presence, as though they were sizing you up. It took a *physical effort* to not back up when they moved toward me, and I went into my *posturing mode*. It was a relief to know that other people couldn't see me make a fool of myself. One woman's image giggled and I felt myself giggling back. Then I noticed how my prejudices kept coming up. I decided that this

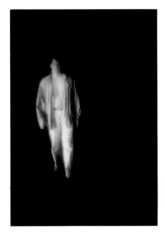 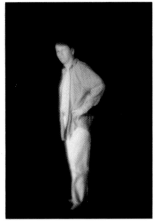 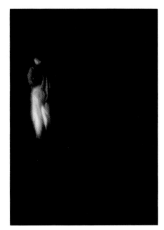

could be something like a great Buddhist piece that showed you yourself, and left you with awareness of your own perceptions and patterns with no way out. Amazingly, even when I went back for a second viewing I felt the *same reactions* coming up, even though I'd just been through this earlier! Like when a "father figure" appeared I went into those automatic father-reactions. There I was posturing with an illusion! The power here of being face to face with a person is just so great that there's no escape from seeing your own feelings. It made me sad to see my own preconceptions about people—to see what we do when we meet people—it's so automatic. You can't control those things but you can *recognize the way the mind manifests.* Painful as it was, this was a safe context to see yourself in, to witness the operations of your own mind. People come and stare at you and you make up all this garbage about them. I had to admit there were people I just wrote

off because they're not the kind of people I normally want to spend time with. I found that I became most engaged with those who were the most different from me—like the black man. When I wasn't immediately open to someone there, I had to acknowledge it was *my* limitation not theirs. When I left the installation I found that it had altered my response to art in general—that I was open to works that otherwise wouldn't have moved me.

TALL SHIPS is a *space that functions as a mirror*. One can look in and see one's responses, both simple and complex, of which one is normally unconscious. Or one can behave in relation to the projections as though they mirrored some possibility of oneself—or one's multiple selves—as in the case of another observer, Jennifer Axinn, who reports standing before the figures and in a sense *becoming* each one in gesture, posture, attitude. (When she illustrated what she had done standing before each figure, almost uncannily one *saw* the persona she imitated to the point of embodiment.) On another level, Chie Hasegawa disturbingly experienced a kind of depression when standing before the Japanese woman who was so withdrawn and out of touch with the viewer; what was mirrored there, it seemed, was the weight of a whole cultural tendency toward passivity and refused communication.

Obviously each person sees a different reality in the mirror. It would seem, then, that the work is no ordinary mirror and, furthermore, that not *only* the work is the mirror. That is, the work is the kind of mirror that shows one that one's own mind is mirroring; and the events, the parts of one's life (such as patterns of reaction) that show up, become somehow conscious—*they* are the images passing before the mirror. In a manner of speaking TALL SHIPS in the first order of response—one's reactions to the video projections—mirrors the mind in such a way that the mind can know itself to be a mirror.

Being on the Verge

I am the mirror in which I am the image.

As rationally tormented as this statement seems, it may be one of those declarations that comes naturally from the experience of video, especially the more reflective video, and this art most especially. Accordingly such a *declaration*—indeed any true declaration in the sense intended here—is *a response to a revealed possibility*[3]. At one level what we are here calling the revelation of a possibility is a fact noticed in the 1970s about the experience of seeing oneself on video[4]. Due to how the medium produces electronic feedback, but also how it allows us to get "feedback" on our own image and behavior (and perhaps how feedback in general relates to neurological activity), video alters self-awareness and, therefore, consciousness itself. (This has to do with how one objectifies subjective awareness in space as well as time.) In the case of TALL SHIPS we are not actually talking about video in this precise sense but the permanently, historically transformed field that devolves from video. In this piece we are dealing with image projection from hidden black-and-white video monitors set up rather simply with commonly available lenses—a technique that, while by no means obvious (no one seems to have been using it at the time but Gary Hill), is technologically trivial[5]. In this sense TALL SHIPS is both literally and figuratively a *projection* of video and the world created by video—the *videosphere*—with complex implications with respect to the ecology of mind (in Gregory Bateson's sense). In any such video-derived ecosphere there is evidently a very special opportunity for self-awareness produced by the nature of feedback in the medium.

In TALL SHIPS, however, we have seen that the first order of self-awareness is psychological—how I respond to the projected images of people coming to meet me—and

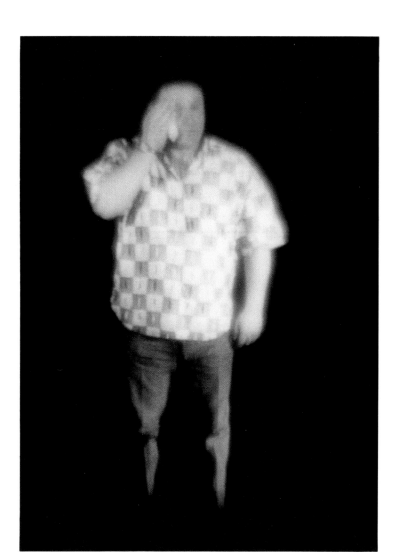

therefore at the technical level not intrinsically related with video (since in theory the projection could be filmic, although the quality of the image, especially the special effect of this particular, soft focus, is a product of video, as is the interactive element). Yet it belongs to the videosphere in the way it works toward immediate transformative awareness; that is, it belongs to the world of feedback rather than the work of filmic representation—image response rather than imagistic representation; instantaneous presence in relation to a provocative image rather than a refined definition of objects either potentially or actually "existing" in the world. Only here we are not speaking about self-awareness through feedback from the medium of video (e.g., a live image of oneself), but from feedback implicit in a work that itself devolves from the videosphere— from the world made possible by video. This has to do with the simple fact that the Gary Hill who made this piece is not Gary Hill the sculptor and obviously not a filmmaker but an artist who happens to be using video here and whose sense of space—whether imagistic or linguistic—derives in part from the possibilities revealed (that is, historically uncovered and created) by the experience of video. We are pointing, in short, to a kind of self-awareness made possible by video and yet unique to the extraordinary conditions of this piece, which obviously transcends the distinction "video art," as well as the cybernetic apparatus of video itself.

We are speaking here, first of all, about being on the verge. The work produces, as noticed above, a particular state of psychological engagement in which we are *going to meet*—but don't. This is a state of apparent incompletion. I reach out but there is no one there to touch. I'm left with a projecting energy and no resting place. In the first instant—the normal moment—I experience this as frustration. In this psychological space I may experience all sorts of emotions, and yet maybe I'll come to see even my

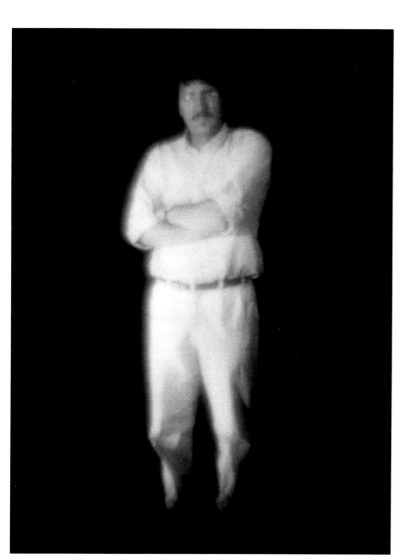

unpleasant tendencies (such as judging the people I see there) as themselves no more than images of the moment cast upon the mirror of my mind. If so, I may be able to experience these complex emotions as themselves not inherently different from the lively images cast upon the wall. And these two sets of images in a certain sense mirror each other—they're alive, they're compelling, they certainly have a life of their own—but they're not *me*, that is, they're not my mind which holds both of them at the same time and yet knows itself as larger than either or the sum of the two. In a certain sense, therefore, these two image sets are just *projections*, and with respect to the self-knowing of my mind it isn't ultimately important whether the projections are psychological or technical/artistic—they're just images in the mirror. In this way the two sets or orders of image *cancel each other out*[6]. What remains? There remains the space in which the mind knows itself as inherently free of both orders of projection, the patterned emotions that arise (the psychological) and the phenomena that provoke us (the world *or* the projected images). And what space is that? It is *the total space of the work itself.* This is the space in which we stand knowing that we are free of identifying with both kinds of projection; it is the space in which you could say that both our personal experience and the "objective content" of the work, as projected images, belong to the *unconscious* of the work as a whole, which is moving toward a *consciousness larger than either,* a realization possible within the *still point*[7] of time and space. It is also the space in which other people are walking, in the dark, their faces catching the light from projected images—like white sails in the moonlight. Tall Ships, as it were, passing in the night. Suddenly, we are inseparable from this total space inhabited by other beings with whom we share the same field of possibilities. This is the field in which, ultimately, *we* are the actual medium of the piece. This is also a field that we share by virtue of our presence

and awareness—a field of pure possibility in which, perhaps, some sort of signal of recognition passes between us, however dim, however barely acknowledged. And—it hardly needs to be said—the field both *is* the piece and yet is not limited by the physical or conceptual confines of the piece. After all, here we are thinking this, and we're not actually there. And indeed you who read this may never have been there at all.

At the Threshold of Intention

Are we contending that what we have observed above is the actual *intention* of TALL SHIPS? The question of intention vexes us in work like this[8].

If we try to see it in the context of conceptual art, we will look for intention as an abstraction that can be read back from a finished or closed object that is arguably its formal equivalent—perhaps its "expression" or even "proof." We believe it is self-evident to anyone willing to openly experience this work that TALL SHIPS (or for that matter Gary Hill's work generally) does not invite form/content meaning-matching, however sophisticated the formulation. The whodunit impulse is quickly frustrated, especially here where the intertextual opportunities of his other works are strikingly absent. The space of the work, the *verge* as it were on which it asks to be met, is radically open—and in fact is designed to stay open. In such a work a more appropriate question is how and where we locate its being—a question perhaps perilously inseparable from how we engage our own being in entering it.

If we conduct our inquiry *in alignment* with the work—in dialogue with it, as it were— we are somehow doing the work of the work. This poses a complex sort of challenge to critical discourse which is not well-equipped to pursue *the further life of the work.*

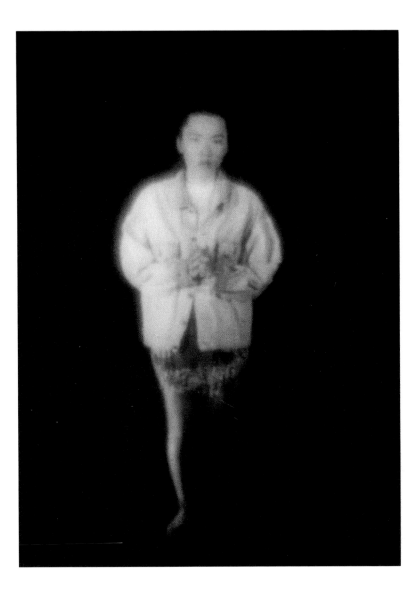

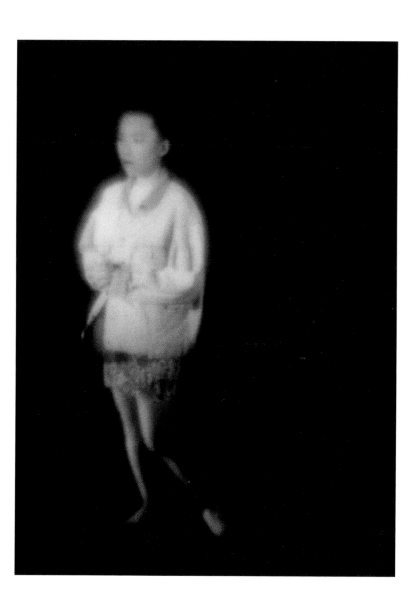

In pointing to, or rather with, this notion we are deliberately deflecting attention away from the work as object so that what we are tracking as its *inner impulse* can somehow have its say. This *further life* is after all something registered in ourselves—something in fact transmitted to us almost imperceptibly—as though the work were a living entity that changes as we change. Fundamentally TALL SHIPS, unlike Gary Hill's more textually intensive works, is annoyingly inaccessible except through our actual engagement with it and its "afterlife," or what is still traceable in our awareness. This is not so much something to reflect upon as something to reflect *out of*. Or, to play this more finely, something that *reflects from us*, where we ourselves are the extended medium of the piece, the Tall Ships still carrying the light borrowed from awareness in the dark.

No wonder critical writing about this piece has tended to break off at precisely that point where what most interests us wants to begin. Perhaps we should speak of *resonance*, that is, how an articulated impulse resonates in us, what it continues to do inside us, what it gives birth to in some complex sense that cannot be conceptualized outside of the work's continuing process. In this sense Gary Hill's way of *engaging with* Blanchot, Heidegger, or Bateson is not to discuss, illustrate or comment on these sources but to *resonate* them—is not, indeed, so much an intertextuality as an extended textuality, a further life. Call it an embodiment of a transmission happening on the verge, at the horizon of the still point, where the impulse was *going to meet*. White sails.

But we were thinking, in a vexed sort of way, about intention. What we are ready to point to now is the very special disposition of authorial intention in TALL SHIPS as something that, like "content" and indeed like the whole hermeneutic enterprise, is all but stripped away. And yet it remains as a mystery of the work. We're not saying that there is no intention, nor that there is a meta-intention, but that *the work is itself the*

cultivation of intention. In a certain sense the intention is set loose by the work. And the work is "complete" at the point where the artist trusts that intention is *not* completed but rather *released*—let go into a field of integrity in which it can truly develop on its own. For us, therefore, the work begins at the *threshold of intention*. So a hermeneutic cannot read back toward a manifest intention, but must read forward into the manifestation of intention as what emerges through engagement. There is, you might say, a *hermeneutic metanoia* or turning around of mind in which the *impulse to read toward the essential truth redirects itself* in order to tease out an emergent possibility. The intention is projective.

The work allows itself to be a vehicle for the transmission of its own intentionality.

Release

Gary Hill releases his work earlier and earlier. This means that he *lets it go* as soon as he can trust that the essential process, the intentional impulse, has been reliably generated. This first sense of release, which is focused largely at the technical and material level, gives over to a second: that the intention is released, *let go into* the work, which is entrusted with the power to realize it. This second sense is connected to a third: the empowerment of the author (therefore the participant) to just *let go*, to be released, inside the work and its intrinsic spaciousness. There is an implication of self-trust, a confidence in balancing, a willingness to ride it out, let come what will. An art of sailing. And this third deepens into a fourth: releasement, as in *Gelassenheit*, the opening to being itself, *letting go beyond* habit and expectation, the (re)orientation toward possibility, life on the verge....

We hold the view that tracking the further life of TALL SHIPS begins with recognizing the special nature of this "verge" and choosing somehow to sustain it within one's awareness. This is not an easy thing to talk about, which might have something to do with the artist's choice to go "wordless" in TALL SHIPS, to date the most uncompromising of Gary Hill's journeys into open intentionality. Yet throughout his work one notices something like a pursuit of processual openness, even in the most textually and imagistically dense pieces. This has to do with the way materials move from work to work, not dialectically but *generatively*—something is triggered in one work that becomes the intentional process of another; something touched off here can be cultivated as intention elsewhere, as its further life. Such a generative modality of composition is inherently improvisational: a note is struck and instantly sets off a process in oneself, a sudden intention released in the space of mind and body that becomes a touchstone for the next moment, the next work, the other person, the hearer. In this sense it's interactive with itself within its own resonant medium and potentially with any participant in the field, any boat sailing the same waters.

Gary Hill embraces this process openly. He doesn't conclude or close down an issue, but opens an inquiry to see how far it will go on its own, within the material terms of a given medium. And when he shows direct interest in "interactive art"—which of course technically applies to TALL SHIPS in that the viewer causes a given figure to get up and approach, sit back down, and return again or not—his is most instructively an interest in possible states of interactivity with given materials/situations. Interaction in this sense is not, as in so much interactive art, a concern with fixed options, the excitation of one-dimensional mysteries, or other amusing predictabilities. Rather it has to do with experiencing choice as the gate of awareness in a given stance, where the circumstance of

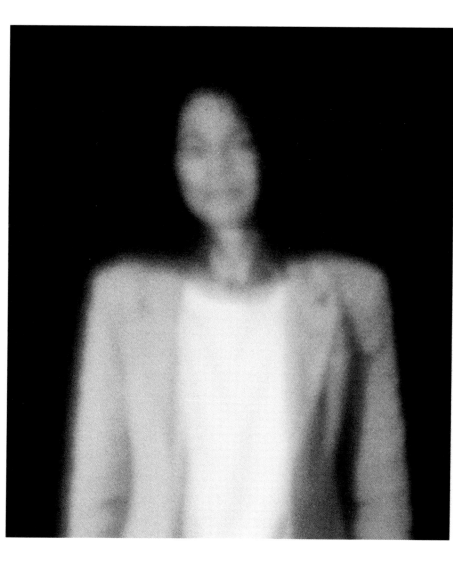

having to choose (do I approach or withdraw? examine my discomfort and anxiety or attempt to turn them away?) opens "perspective incongruities" played against the resonant possibilities—angles of (co)incidence. Openness here is never far from catastrophe—the thrown-downness of sharpened attention and the spun-aroundness of sudden presence. Allow us to further illuminate our point.

A *verge* is also a spindle, in one of its meanings, a pole, a center in a rotatable body, the core of self-orientation and radical alignment that permits one to balance. And it has to do with optimum receptivity, what we call *being centered*. Far from being a fashionable "New Age" cliché, centeredness is a technically definable state, at least on the physical level: it is where a living body finds its center of gravity as if by dropping a plumb line through the very center of its physical being and discovers a state in which tension feeds inward from the extremities and is *neutralized*. If you will permit us a short diversion, we can pass on a simple "pointing out" instruction (called, for fun, "Applied *Gelassenheit*"), given to us two decades ago by a t'ai chi (or tai-ji) teacher, which vividly illuminates this state (can it really, like they say, "change your life"?). The only hard part is that you have to stand up to get it, and ideally have someone read out loud the following how-to exercise:

HOW TO JUMP (INTERRUPTUS)

Stand up; and at the command
"On you mark, get set, go!"
you jump.
OK, ready? Now:
On your mark...,
get set...,

...

(Notice the state of your body.)

Simple, no? Of course you have to actually do it (probably at least twice) to get the point, and maybe allow yourself the luxury of feeling a little silly. If you observe well the *state of incompletion* at precisely the *moment before* you would have jumped, your conscious mind will catch a fleeting phenomenon: *complete release*. This is based on a physical fact: You cannot jump without releasing all of your weight down into the ground. In what amounts to a literally radical (rooted) event, you have dropped yourself—and made your most direct contact with the "center," in this case actually the center of the planet, reached by way of "gravitational surrender." (The poet Charles Olson has spoken of "that freshness to the experience of time that gravity affords.") You are on the verge. And you are noticing a common fact of nature that you may never have noticed before: The Still Point. Some people experience vertigo out here on the verge, but those who manage to "hang in" report experiencing a lucidity like waking up in a dream. If you can stay with this neutral state a few extended moments, you can get to know this stance of No Holding, something *soft yet alert* and rather like Being Held, embraced as it were by Mother Earth herself. This is the famous t'ai chi state, and if you maintain it while moving, you're "doing" t'ai chi; you're embodying the self-balancing potential of a body in water, its center of buoyancy just below the surface—just below visibility and conscious scrutiny. And in your movement you resemble nothing so much as a tall ship. The ancient Chinese said that the secrets of nature are overlooked in the simplest ordinary moments.

The poet Robert Duncan remarked, "I have the feeling that I take place *out there*." It is not a matter of my world vs. your world, or either of these vs. *the* world, but a space

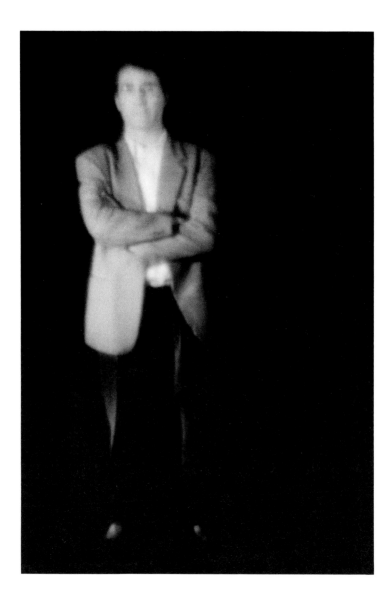

in which we stand revealed to ourselves and align with this process in others. Imagine: Tall Ships glimpsing their own signals, interactively, reflectively. In this view our reflections *on* the medium (even here, now, where we are engaged in carrying on the further life of the work) are both intrinsically and manifestly dialogical; and so they are reflections *of* the medium as well. The signals are transmissions moving back and forth between us, illuminated as it were by the light of our own projections. If I can let go of my expectations, I neutralize the dynamic of contact/frustration and enter the receptivity, the space of listening, in which transmission most profoundly occurs. The membrane between viewer and projection in TALL SHIPS becomes permeable, and, even though there is obviously no direct contact between the two, the work itself becomes a medium of exchange. The transactions, in this *state of release,* occur very gently and by indirection, both in what we call real and possible space, which together constitute the total space of the work.

This total space has a life of its own, is alive—like the integrated aliveness of a swamp and its field of signals, the dance of fireflies, the concert of bull frogs and tree frogs.... We become strangely inarticulate when we try to point to the objective consciousness at work there. We might as well try to account for the dialogue of ships passing in the night.

Is the Piece About Language?

In our dialogue Gary Hill raised the question of language in a "silent" work: "Is the piece about language?" And Charles Stein replied, "If you say so." The piece is about language *if you say so.* The event of the piece is *the activity of the total space...* if you say so. In ordinary language, "if you say so" means "I'll grant you your point for the sake of

argument, but I don't really know that it's so." In the language of *the discourse of the further life of the work,* it means that the authentic *possibility of the claim* is, for the willing participant, *the truth of the claim*. (This sense of truth, by the way, is true beyond any specific claim to be true.) In this domain it can be said that *the piece creates a space in which the claim of the reality is the reality of the claim*. (This sense of reality, by the way, is real beyond any specific claim to be real.) What's at stake here, we are claiming, is the ontological power of declaration. (Not that any ol' thing you say is true, but that nothing is true unless you say so—declare its truth.) And the *site* of that power, as regards our participation in *this work*, is a point of interference between aesthetic, ontological and (if, and only if, you say so) theurgical possibilities.

TALL SHIPS, in its (not minimalist but) stripped down state, is an uncompromising declaration of a poetics of the *event of a total space*. The underlying principle here is*: A true declaration is a response to a possibility.* You may grasp a possibility in such a way that its recognition is already a declaration, whether or not a specific verbal declaration occurs in fact. The space of language is pervasive with or without words. At the verge of communication, where you stand in the piece, you may feel the pressure of the possibility of speaking. Eventually you may feel that in this context your very presence is linguistic.

Yet our only inevitable act of engagement in *language as words* is of course centered on the title. The title is unaccountably impactful, and a rather mysterious verbal object. It seems to launch an inquiry into its own meaning that resonates in the space, bringing us back to awareness of ourselves as material to the medium. A one-line poem in which our own reflections and further reflections radiate outward—a stone in the mind pond…. Well, maybe the mystery of the title is a kind of permission. It might, for instance, permit one to replace the old self-centered gesture of "walking tall" with a

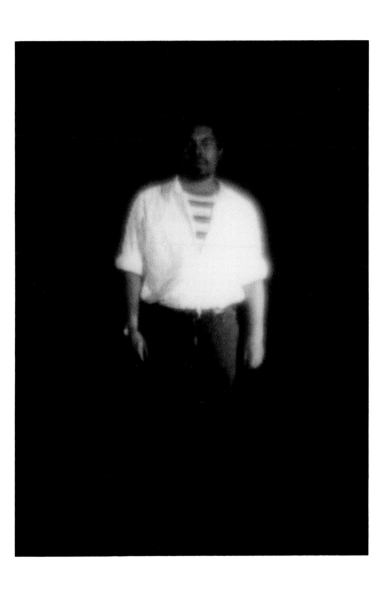

space-centered gesture of "seeing tall": If I say, *I am seeing tall*, do I mean, "I see in the dark," or "Even though it's dark I see clearly," or simply, "I see..."? Night vision, any vision. A personal intrusion: In my second visit to the piece I noticed that my companion Susan Quasha at one point was sitting on the floor watching the people watch the projections. Out of this I became aware of the mirror-like quality of the space, of myself there as text, and of my presence as linked to what could not be disclosed by disclosure. From such awareness one can't help wishing for an alternative species of "pointing out"—preparing one to meet the "event of the total space" as it actually emerges. This pointing out would be a central gesture and act of implicit communication—a process, in truth, of direct transmission—which we have hoped to locate in the notion of a "further life of the work."

Reading Back from TALL SHIPS

It is a natural tendency to want to read back from an apparently pivotal work to see in earlier works the origins of these new or important insights[9]. Reading back from the present point of focus is of course the core hermeneutic impulse; and we have noticed that this impulse is problematic where it interferes with the radical openness of the work, which asks us in some sense to read forward or outward from the center (the verge). In the case of TALL SHIPS a useful kind of reading back would move toward tracking an actual tendency, present throughout the artist's work, to strip away the thing he was relying on in previous works—language as text, highly refined images, various kinds of control, etc.[10] What we notice, most powerfully in TALL SHIPS, is that the stripping down is like alchemical distillation (alembication) in the way it compresses what

remains to a kind of breaking point: In this case the break is *out*—out of the phenomenological limitations which our own methods and habits invisibly impose, out of the very hermeneutic process in which even now we are engaged—out into the total space, both physical and mental, of the actual participants moving through the work and its afterlife.

This breaking out is also an embrace. Like the gesture of the child, Anastasia Hill, who with light in her face and opening arms rushes toward us from the far end of the dark hall. Perhaps in going to meet us she is christening the vehicle in which we travel together, yet another tall ship with white sails.

<div align="right">

GEORGE QUASHA *in dialogue with* CHARLES STEIN
BARRYTOWN, NEW YORK, JULY 14, 1993 / MAY 17, 1997

</div>

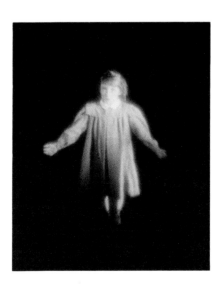

Notes to "Tall Acts of Seeing"

[1]In their original or pre-engaged position in the piece the figures may be seated, standing or (in one instance) lying down. The Whitney exhibit (New York, 1993), in a hall about 65 feet long, consists of 12 projected images of the following individuals, respectively: *Left wall:* Bill Colvin, Santha Cassel, Ronald Choate, Sharon Parker, Megan Adcock, Mark Vandevanter; *back wall:* Anastasia Hill; *right wall:* Lou Hetler, David Cheung, Terri Colvin, Katsura Ozeki, Preston Wadley. In the full version of this piece, shown at both Documenta IX (Museum Fridericianum, Kassel, 1992) and the Stedelijk (Amsterdam, 1993), in a hall about 90 feet long, the order is: *Left wall:* Bill Colvin, Preston Wadley, Ronald Choate, Santha Cassel, David Cheung, Sharon Parker, Megan Adcock, Mark Vandevanter; *back wall:* Anastasia Hill; *right wall:* Greg Hill, Lou Hetler, Richard Parker, Terri Colvin, Donald Young, Jay McLoughlin, Katsura Ozeki.

Gary Hill did not select these people, by the way, because they are representative or in any special sense "powerful"; the approach to choice was casual, often with a strong element of chance, and always personal (through a network that included family and acquaintances) or, if you will, intuitive. The only instruction given to them during the video taping was that they should walk toward the camera and remain at a given point for about 20 seconds but wait for a signal to return to the original spot; Gary Hill always waited much longer, which tended to make them a bit uncomfortable—or at least to foreground for them the issue of comfort in the situation of being stared at. A lot could be said about one's various reactions to specific individuals, and it's tempting to do so; this certainly could have a kind of value, especially in an extended discussion of the work, but it does not seem to me to serve the present line of thought. The most important point here is that the non-symbolizing modality of selection contributes to the radical openness of the field of experience.

[2]The people whose experience we report here were chosen not because they make art, which they happen to do, or because they're friends of ours, which they happen to be, but because their responses are interesting and express a range of possible reactions. However, they are in no sense held to be typical, precisely because there can be no meaningfully typical instance in a field that is intentionally unbounded at the semiotic level.

[3] This is a somewhat special use of *declare:* To publicly affirm an intuited possibility with the intent of actualizing it in such a way that the reach of that possibility is not lost. What I declare is not simply frozen in static reification; rather, the source of my intuition which has given force to my declaration is lifted into manifestation and becomes an ongoing resource. What now becomes real remains resonant with its root possibility. A declaration is grounded in the recognition of what is intuited to already be the case.

[4] During the foundational period of video art in the 1970s, when the technology became accessible to many individuals, one of the many experimental groups was called "EarthScore" (in which Paul Ryan figured, along with Stephen Kolpan and Robert Shuler), working in New York's Hudson Valley, which counted among its interests the discovery that the video medium had a transformative impact on consciousness and potential ecological implications. Corresponding as it did to parallel interests of artists using video (Bruce Nauman, Vito Acconci, Linda Benglis), this work engaged the attention of many of us, including, we believe, Gary Hill.

[5] It goes without saying that Gary Hill's work is often very rich and challenging at the technological level, notably in pieces like *Disturbance (Among the Jars)* (1988) and *Between Cinema and a Hard Place* (1991). Hence the importance of noting that the technological is explicitly not the level of intentional attraction in *Tall Ships*, where preoccupation with technology (even "interactive art") can serve as a serious distraction from the real issues. The discovery of the projection technique was in fact fortuitous and took place many years ago in Barrytown, New York, when he returned home in the evening to discover a focused projection on the dark wall in his workshop: A video monitor left on was projecting through the viewfinder on his camera, which of course is just a lens.

[6] In conversation with us about this and related issues—the elusive way that quite separate but somehow parallel orders of experience "cancel out" and cease to dominate the foreground of awareness—Gary Hill offered an interesting analogy: the way noise reduction is done in a sound studio. The general idea is that you take an audio signal (displayed as a pattern) and its inversion, and then superimpose one pattern on another; the initial sounds (e.g., the music) cancel out, and what remains is the noise (or what would normally be eliminated). In our application of this analogy (which in a sense reverses the usual idea about what is regarded as desirable and undesirable

content), the dominant sounds that cancel out are the two sets or orders of image, and the "noise" is what the work really is—what remains, what stands outside a direct phenomenological description.

[7]"Still point" will be familiar to readers of T.S. Eliot's poem "Burnt Norton" (the first poem of *The Four Quartets*), section II: "At the still point of the turning world. Neither flesh nor fleshless; / Neither from nor towards; at the still point, there the dance is, / But neither arrest not movement...." This vision of suddenly realized timelessness ("To be conscious is not to be in time") derives from Dante's vision of eternal stillness in the last canto of the *Paradiso*. Interestingly, "still point" is used as a technical term in Craniosacral Therapy, an offshoot of Osteopathy, for the act of causing a momentary suspension in the fundamental pulsation of the body (the "craniosacral rhythmical impulse"); the effect is to mobilize the system's inherent ability to self-correct. This notion has implications for our discussion of "Release" below: that the experience of the Still Point is "wholeness" (as in "health") and engages inherent self-balancing.

[8]We use "intention" and "intentionality" in the ordinary sense of will, purpose, and aim, and not for the general structure of consciousness as in Husserlean and other phenomenologies.

[9]There are those, for instance, who now want to find Gary Hill's interest in Gnostic texts active throughout much of the pre-*Disturbance (Among the Jars)* (1988) work. Historically this is incorrect, because when I [GQ] introduced the Gnostic Gospels into our collaboration on *Disturbance* in Paris, Gary Hill was not familiar with them. Yet he took to them in a way that showed what you could call a Gnostic propensity—and with the pebble-in-the-pond effect it seems to resonate atemporally through much of his work. This is not wrong; it's one kind of discovery, and one that may illuminate something at the core of his work—that it drives toward sudden awareness, a gnosis or spontaneous reframing of everything at the ontological level. You can see, for example, how in URA ARU (1986) the proliferation of reversals (palindromes, reversed sequencing of frames, etc.) are at the deepest level pushing at a kind of metanoia or instantaneous turning around of the mind at root.

[10]For instance, his early almost voluptuous experiments with video synthesis are optimally reduced to syntactically framed and semantically rich moments already in *Videograms* (1980-81).

Interview with Gary Hill on TALL SHIPS

Conducted by Regina Cornwell[1]

Regina Cornwell: *Tell me about* TALL SHIPS, *about the title itself and the experience you wanted to nurture through this installation.*

Gary Hill: During recordings for the piece I happened to see an old photograph taken in Seattle around 1930 of a "tall ship." I think they were removing the last of the old ships from the Seattle harbor. I immediately associated those huge masts and full sails with people standing, like the people I was working with. The thought of that kind of ship on the high seas—that frontal view of extreme verticality coming towards you. There's a majestic quality to it that when applied to the human figure projects a kind of power and grace. That person, however vulnerable, will come forth no matter what. It's the simplicity of the idea—humans approaching humans in the space of a work that is always slightly haunted by the notion of "ships passing in the night." I don't think I was really clear about the piece until I had this title.

What was your methodology for the production of the work? How did you direct the people and transcribe it to such an extreme space?

I wanted the whole situation to be unassuming. All the people are family, friends and friends of friends that were spontaneously gathered for the moment. I gave very little instruction during the recordings. Typically, I would have a person walk up to me while I was taping, and, after awhile, they would expect the "scene" to be over. I would leave

them hanging there considerably longer than their expectation waiting for that moment of release—when someone gives in to just being there and slowly opens up in a different kind of meeting space. I eliminated the possibility of theatrics as much as possible and tried to avoid any kind of aesthetic overtone. From the time of conceiving the piece to actual production I simplified the movement of the people to only coming forward and then returning to their particular place and posture of either standing or sitting. There are a few variations on that, for instance, after coming halfway forward they might pause and go back, or they might come back a second time after beginning their return.

The people in TALL SHIPS *seem to be from a variety of cultural backgrounds, ages, genders, and physical types. Is there some specific significance to this fact's occurring in such an interactive piece?*

TALL SHIPS is not really about interactive art and it's not about multiculturalism. It's simply the idea of a person coming up to you and asking "Who are you?" by kind of mirroring you and at the same time illuminating a space of possibility for that very question to arise. Basically I wanted to create an open experience that was deliberate and at the same time would disarm whatever particular constructs one might arrive with, especially in a museum.

What is the significance of the child at the end of the hall? Being the only child and positioned at that location it seems more purposeful perhaps than other aspects of the piece.

Originally I hadn't intended to have someone at the end position, but while we were installing it, I saw that the blank void suggested too much a sense of the infinite. Without any figure there the others would seem to go on forever like the infinite reflections

bounced between facing mirrors. I wanted a delimitation of the space that would retain a sense of place, and positioning a person there seemed to work. I decided on the child suggesting a future or an on-going sense of openness and possibility.

At Documenta IX I had a sense of anxiety in the space. I couldn't see, it was really very dark, but at the same time it was an extraordinary experience…

I think this anxiety is very much a part of the ingress. Once you're in and over your initial trepidation then perhaps some questions arise: "What kind of a space am I in?" "How long is it?" "Who are these figures?" "How long will they look at me?" "Am I making them move?" "Can I talk?" These questions are not so much answered as slowly illuminated both figuratively and literally. As the figures come forth they provide the light in the space. Silhouettes of other viewers begin to appear. You begin to see the shapes and shadows and light cast by the figures onto people's faces. It's very subtle, but the viewers begin to mix with the projections.

Is this a radical departure from other installations?

Well, yes and no. There are technical aspects and to some extent "content" that are very close to *Beacon (Two Versions of the Imaginary)*[2]. In *Beacon* there are two different images projected out through the ends of a tube. The tube rotates very slowly in an equally darkened space, and the images continually expand and contract around the room. Technically, the projections of both *Beacon* and TALL SHIPS were obtained in the same way, so the visual quality of the images is very similar. The same kind of "assemblage" projectors are used, made from small black and white monitors and surplus projection lenses. Like in TALL SHIPS, in *Beacon* there are a number of full figured images

in the opening sequence which were recorded with a rotating camera that moved counter to the projections in the installation. This in effect cancels out the movement so that it looks like a spotlight (or beacon) passes across the people, illuminating them, and this also happens to the viewers in the space as well.

Beacon (Two Versions of the Imaginary) (1990)

How is this related to TALL SHIPS? *Did you have a similar connection to the people and how you worked with them?*

I used a similar approach in recording the people. With the exception of the two readers reciting the text, the people are seen looking or watching. In both works the viewers and the viewed are intertwined in a number of ways. Certainly with *Beacon* the structure was more conceptual and the people, at least the standing figures (what we referred to as "gazers" during production) were each playing a part, that is, of someone following the light. On the other hand the two readers were very much involved in finding their own voices and their relationship to one another within the Blanchot text. There's an incredible emotional undertow to those readings that I think had to do with the fact that these two people were together and they were connecting through this text in a way they hadn't before and I think it came as somewhat of a surprise. I hadn't thought of it before but it's interesting to think about the relationship between a beacon and a ship.

Beacon (Two Versions of the Imaginary) DETAIL (1990)

There also seems to be some connection with Disturbance (Among the Jars)[3] *especially in the way you may have worked with the performers. From what I understand there was a considerable amount of improvisation incorporated into that piece too.*

In *Disturbance* the people who recited and performed were very much left up to their own devices much like the people in TALL SHIPS. They were walking into a kind of envelope of time whereas the participants in *Disturbance,* you could say, walked into the Gnostic texts and let come what may. In particular, the writers—philosopher Jacques Derrida and poets Bernard Heidsieck, Claude Royet-Journoud, Jacqueline Cahen, Joseph Gugliemi, and Pierre Joris—all reworked their selected texts, performing them as unique events without any knowledge of an overall script. George Quasha had a lot to do with this. In fact he suggested using the Gnostic texts in the first place, and we collaborated on selecting the specific texts and performers and worked together with the readers toward keeping their relationship to the text free and spontaneous. But even when we were finished with recording these "performances" I had no idea how everything would get woven together. So there's a shared attitude in the making of these works that I suppose has something to do with surrender, of really going with "let's see what happens." In the end it took me six months to edit the piece. There's a phrase in the *Gospel of Thomas*[4] that goes a long way if you're willing to follow it through: "What will you do when you are in the light?"

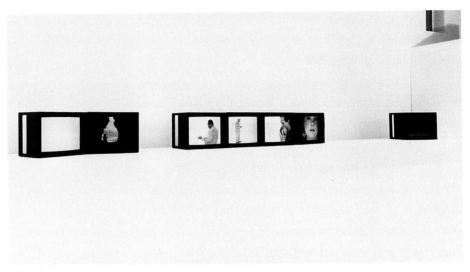

Disturbance (among the jars) (1988)

Disturbance (among the jars) DETAILS (1988)

Given the complexities of the textual layering in most of your work, the absence of sound and the interactive aspects of TALL SHIPS *would seem to point in a new direction.*

Suspension of Disbelief (for Marine)[5] is silent too, but I think that the silence in TALL SHIPS is more active—it feels present in a way. It makes the impending contact really out in the open. One's thought is kind of naked as if you are out on "mind island" with this person and you feel there must be something to say. And what does one possibly say when it's radically stripped down to this point? I think this kind of space is also very uncomfortable for some people. Instantly they want to fill it with talking.

How does this relate to the interactivity that is involved in the piece?

The possibility of working with interactive systems has always been in the back of my mind or a thorn in my side depending on the context I'm thinking in. I wanted the interactivity to be virtually transparent to the point that some people would not even figure it out. I didn't want somebody going in there and, in a sense, playing. I mean "play" like cause and effect—I'm pushing this thing and so this is happening. I think this is the major problem with interactive work in general. You have to find a way around the mind being told where and when it may make a choice. It has to kind of dawn on the mind.

In the Pompidou exhibition catalogue, Lynne Cooke quotes you as saying: "If I have a position it is to question the privileged place that image, or for that matter sight, hold in our consciousness." In the light of your strong concern with language, especially in your single-channel tapes, there's also this quote: "Language can be incredibly forceful material: there's something about it where if you can strip away its history, get to the materiality of it, it can rip

into you like claws, whereas images sometimes just slide off the edge of your mind as if you were looking out of a car window."

Quotes like anything have their context. I'm really looking for another way outside the current theoretical issues concerning language and image. I am still very interested in the image being experienced self-consciously rather than it merely being a given. In this sense I'm not referring to the media frame of the image and its representation but rather the process of seeing and how that's linked to thinking and language. I think this comes through particularly in my installation work in which the viewer is an integral part of the event and that she or he, in a sense, completes the "circuit" of the work. This is especially true in TALL SHIPS and to a certain extent *Beacon*. On a more strictly perceptual level this might simply be the negotiation of images that migrate through a space, as in *Suspension of Disbelief* and *Between 1 & 0*[6] where images exist for fractions of seconds and only become "seen" as part of a "swarm" of accumulated images that illuminate a kind of trace.

In your early work you were very much concerned with feedback phenomena. How has this interest continued in your more recent work?

I'm finding myself once again engaging the possibilities of feedback inherent in electronic media, however, more directly having to do with people. There is a profound difference here that has to do with a kind of presence which enfolds a real time mediation of viewer, viewed, signifier and signified that are continually shifting positions. It allows for other kinds of thinking—a kind of action that brings about a real change in the world and our sense of it. The feedback really makes possible a special state that, in turn, further engages an ontological space where, at their boundaries, art and life mutually fold into each other.

Do you see TALL SHIPS *and other recent works as phenomenological, insofar as you are interested in language and thinking about the constant problem of the mind/body, subject/ object split?*

But I'm not thinking about the constant problem of the "mind/body, subject/object split" at all. My working methodology is not one of theorizing and then applying that to making art. In each work I find myself committed to a process that of course may involve material where such philosophical issues may seem to be relevant. But I'm committed to the idea that the art event takes place within the process. One has to be open to that event and be able to kind of wander in it and feel it open up; to see it through until some kind of release feels inevitable. I'm getting further and further into finding this moment in processes that involve me with people.

Today there is more and more installation work which involves media such as video or new technologies, and there is an increase of interest in it, but it is still slight. In terms of a response from the art press, why do you think that it is so minimal and why, when it is there, it is so critically and theoretically underdeveloped?

The "object" has been revered for so long and it's so much a part of the economic base of art that to get into installation work people really have to have an experience that turns their mind and breaks their habit of wanting *things*. Even conceptual art was assimilated more easily into art culture because in the end there was still some sort of static object that you looked at, even if it was only the photographic or textual documentation put in a frame. But once you ask the viewer to enter the real time presence of the work—that is, that you want their *time*—there's another kind of expectation.

Performance, installation and media art each in its own way resides somewhere between theater and cinema, on the one hand, and the plastic arts on the other. I think this is what gives them a certain flux—their "cultures" have more inputs and outputs—by nature they are more interactive and driven by intermedia tendencies. Most of the time this kind of work falls between the cracks. Either you have theoreticians applying the likes of Baudrillard and/or stealing ideas from McLuhan but nevertheless completely missing the work for the simple reason that they do not attend to the work itself. Or you have an art critic who comes from a good historical knowledge of work involving objects and images but doesn't have a clue about technological systems and is not accustomed to considering an art that is ontologically based, i.e., that seeks to extend both what art and the world *is* by exploring possibilities through new media and in new combinations.

Notes to Interview

[1]The first version of this re-edited interview conducted by Regina Cornwell was published in *Art Monthly,* October 1993, No. 170.

[2]*Beacon (Two Versions of the Imaginary)* (1990): two-channel video installation (NTSC, black-and-white, sound), with 2 modified video monitors, two projection lenses, synchronizer, aluminum pipe, and motor.

[3]*Disturbance (among the jars)* (1988): seven-channel video installation (PAL, color, sound) with seven modified video monitors (removed from their outer casings), synchronizer, white platform, and seven wood chairs. Monitors are arranged in three groups, and images flow across the screens, presenting single images and sometimes rapidly shifting views. Nine poets and a philosopher walk while reciting passages from the Gnostic Gospels, principally in French but translated and intricately improvised from and to several languages.

[4]The quote from "The Gospel of Thomas" (several translations exist, including in *The Nag Hammadi Library*, ed. By James M. Robinson, San Francisco: Harper & Row, 1997) is an "original" rendering based on the free use of Gnostic texts in *Disturbance (among the jars)*. In the original interview this quote was misascribed to *The Gospel of Mary*, one of the other texts used in *Disturbance*.

[5]*Suspension of Disbelief (for Marine)* (1991-1992): four-channel video installation (NTSC, black and white, silent) with thirty modified monitors, computer-controlled video switcher, and aluminum beam.

[6]*Between 1 & 0* (1993): two-channel video/sound installation, with ten black and white monitors mounted on two aluminum ladders, two speakers, and spoken text.

Gary Hill biography

SELECTED SOLO EXHIBITIONS

1997

Westfälisches Landesmuseum, Münster, Germany

1996

Galleria Lia Rumma, Naples, Italy

Galerie des Archives, Paris, France

Donald Young Gallery, Seattle, Washington

Barbara Gladstone Gallery, New York, New York

White Cube, London, England

"Gary Hill: *Withershins*," Institute of Contemporary Art, Philadelphia, Pennsylvania

Kunst- und Ausstellungshalle der Bundesrepublik Deutschland, (Forum), Bonn, Germany

1995

"Gary Hill," Moderna Museet, Stockholm, Sweden (Scandinavian touring exhibition organized in collaboration with Riksutställningar, Stockholm, Sweden)

1994-95

"Gary Hill," (travelling exhibition organized by Henry Art Gallery, Seattle, Washington). Travelled to: Hirshhorn Museum and Sculpture Garden, Washington D.C.; Henry Art Gallery, Seattle, Washington; Museum of Contemporary Art, Chicago, Illinois; Museum of Contemporary Art, Los Angeles, California; Guggenheim Museum SoHo, New York, New York; Kemper Museum of Contemporary Art and Design, Kansas City, Missouri

1994

"Gary Hill," Musée d'Art Contemporain, Lyon, France

"Imagining the Brain Closer than the Eyes," Museum für Gegenwartskunst, Öffentliche Kunstsammlung, Basel, Switzerland

1993

"Gary Hill: Sites Recited," Long Beach Museum of Art, Long Beach, California

"Gary Hill: In Light of the Other," Museum of Modern Art, Oxford, England (organized in collaboration with the Tate Gallery Liverpool)

"Gary Hill," Donald Young Gallery, Seattle, Washington

1992-93

"Gary Hill," (travelling exhibition organized by the Centre Georges Pompidou, Paris, France). Travelled to: Musée National d'Art Moderne, Centre Georges Pompidou, Paris, France; IVAM Centre Julio Gonzalez, Valencia, Spain; Stedelijk Museum, Amsterdam, The

Netherlands; Künsthalle, Vienna, Austria

1992
Stedelijk Van Abbemuseum, Eindhoven, The Netherlands

"Gary Hill," Le Creux de L'Enfer, Centre d'Art Contemporain, Thiers, France

"I Believe It Is an Image," Watari Museum of Contemporary Art, Tokyo, Japan

1991
Galerie des Archives, Paris, France

Nykytaiteen Museo: The Museum of Contemporary Art, Helsinki, Finland (retrospective of videotapes)

1990
Galerie des Archives, Paris, France

Galerie Huset/Ny Carlsberg Glyptotek Museum, Copenhagen, Denmark

Museum of Modern Art, New York, New York

1989
Kijkuis, The Hague, The Netherlands

Musée d'Art Moderne, Villeneuve d'Ascq, France

1988
Western Front, Vancouver, B.C., Canada (screening)

Espace lyonnais d'art contemporain (ELAC), Lyon, France (retrospective screening of videotapes)

1987
Museum of Contemporary Art, Los Angeles, California

2nd Seminar on International Video, St. Gervais-Genève, Geneva, Switzerland (retrospective screening of videotapes)

1986
Whitney Museum of American Art, New York, New York (retrospective screening of videotapes)

1983
International Cultural Center, Antwerp, Belgium (screening)

The American Center, Paris, France (retrospective screening of videotapes)

Whitney Museum of American Art, New York, New York

Monte Video, Amsterdam, The Netherlands (screening)

1982
Galerie H at OregonF, Steirischer Herbst, Graz, Austria

Long Beach Museum of Art, Long Beach, California

1981
The Kitchen Center for Music, Video and Dance, New York, New York

And/Or Gallery, Seattle, Washington

1980
Media Study, Buffalo, New York

"Video Viewpoints," Museum of Modern Art, New York, New York (screening)

1979
The Kitchen Center for Music, Video and Dance, New York, New York

Everson Museum, Syracuse, New York

1976
Anthology Film Archives, New York, New York (screening)

1974
South Houston Gallery, New York, New York

1973
Woodstock Artists' Association, Woodstock, New York

1971
Polaris Gallery, Woodstock, New York

SELECTED
GROUP EXHIBITIONS

1997
"Angel, Angel," Kunsthalle Wien, Austria

"The Twentieth Century: The Age of Modern Art," Martin Gropius Bau, Berlin, Germany; travelled to: Royal Academy of Arts, London, England

1996-97
"Being and Time: The Emergence of Video Projection,"

(travelling exhibition organized by the Albright-Knox Art Gallery, Buffalo, New York). Travelled to: Cranbrook Art Museum, Bloomfield Hills, Michigan; Portland Art Museum, Portland, Oregon; Contemporary Arts Museum, Houston, Texas

Hamburger Bahnhof-Museum für Gegenwart, Berlin, Germany

"The Red Gate," Museum Van Hedendaagse Kunst Gent, Belgium

1995
"ARS '95 Helsinki," The Finnish National Gallery, Helsinki, Finland

"Identità e Alterità," Venice Biennale, Venice, Italy

Carnegie International, Carnegie Museum of Art, Pittsburgh, Pennsylvania

Biennale d'Art Contemporain, Lyon, France

1994
"Múltiplas Dimensões,"

Centro Cultural de Belém, Lisbon, Portugal

"Cocido y Crudo," Centro de Arte Reina Sofia, Madrid, Spain

São Paulo Bienal, São Paulo, Brazil

"Facts and Figures," Lannan Foundation, Los Angeles, California

1993
"American Art in the 20th Century, Painting and Sculpture 1913-1993," Royal Academy, London, England; Martin -Gropius Bau, Berlin, Germany

"Eadweard Muybridge, Bill Viola, Giulio Paolini, Gary Hill, James Coleman," Ydessa Hendeles Art Foundation, Toronto, Ontario, Canada

"Passageworks," Rooseum, Malmö, Sweden

"The 21st Century," Künsthalle Basel, Basel, Switzerland

"Biennial Exhibition," Whitney Museum of American Art, New York, New York

1992

"Performing Objects," Institute of Contemporary Art, Boston, Massachusetts

"Metamorphose," St. Gervais-Genève, Geneva, Switzerland

"Manifest," Musée national d'art moderne, Centre Georges Pompidou, Paris, France

"Art at the Armory: Occupied Territory," Museum of Contemporary Art, Chicago, Illinois

"The Binary Era: New Interactions," Musée d'Ixelles, Brussels, Belgium

"Documenta IX," Museum Fridericianum, Kassel, Germany

"Doubletake: Collective Memory & Current Art," Hayward Gallery, London, England

Donald Young Gallery, Seattle, Washington

1990-92

"Passages de l'image," Musée national d'art moderne, Centre Georges Pompidou, Paris, France (travelling exhibition organized by the Centre Georges Pompidou, Paris, France) Travelled to: Fundacio "la Caixa," Barcelona, Spain; Wexner Art Center, Columbus, Ohio; San Francisco Museum of Modern Art, San Francisco, California

1991

"Biennial Exhibition," Whitney Museum of American Art, New York, New York

"Metropolis," Martin-Gropius-Bau, Berlin, Germany

"Topographie 2: Untergrund," Wiener Festwochen, Vienna, Austria

"Artec '91" International Biennale, Nagoya, Japan

1990

"Tendances multiples (Videos des Annees 80)," Musée national d'art moderne, Centre Georges Pompidou, Paris, France

"Energieen," Stedelijk Museum, Amsterdam, The Netherlands
"Bienal de la Imagen en Movimiento '90," Centro de Arte Reina Sofia, Madrid, Spain

1989

"Video-Skulptur Retrospektiv und Aktuell 1963-1989," Kolnischer Künstverein, Cologne, Germany (travelled to Berlin and Zürich)

"Video and Language," Museum of Modern Art, New York, New York

"Delicate Technology, 2nd Japan Video Television Festival," Spiral Hall, Tokyo, Japan

"Les Cent Jours d'Art Contemporain," Centre International d'Art Contemporain de Montreal, Montreal, Quebec, Canada

"Eye for I: Video Self-Portraits," Whitney Museum of American Art, New York, New York

1988

"As Told To: Structures for Conversation," Walter Philips Gallery, Banff, Alberta, Canada

1987

"Documenta VIII," Museum Fridericianum, Kassel, Germany

"Contemporary Diptychs: Divided Visions," Whitney Museum of American Art, New York, New York

"The Situated Image," Mandeville Gallery, University of California at San Diego (UCSD), La Jolla, California

"The Arts for Television," international travelling exhibition organized by the Museum of Contemporary Art, Los Angeles, California, and the Stedelijk Museum, Amsterdam, The Netherlands

"Cinq Pièces Avec Vue," Centre Génevois de Gravure Contemporaine, Geneva, Switzerland

"Japan 87 Video Television Festival," Tokyo, Japan

1986

"Video: Recent Aquisitions," Museum of Modern Art, New York, New York

"Video and Language/Video as Language," Los Angeles Contemporary Exhibitions (LACE), Los Angeles, California

"Resolution: A Critique of Video Art," Los Angeles Contemporary Exhibitions (LACE), Los Angeles, California

"Collections Videos—Acquisitions Depuis 1977," Musée National d'art Moderne, Centre Georges Pompidou, Paris, France

"II National Video Festival of Madrid," Circulo de Bellas Artes, Madrid, Spain

"Poetic License," Long Beach Museum of Art, Long Beach, California

1985

"Biennial Exhibition," Whitney Museum of American Art, New York New York

"Image/Word: The Art of Reading," New Langton Arts, San Francisco, California

1984

"Biennale di Venezia," Venice, Italy

"So There, Orwell 1984," The Louisiana World Exhibition, New Orleans, Louisiana

"Video: A Retrospective," Long Beach Museum of Art, Long Beach, California

1983

"Art Video Retrospectives et Perspectives," Palais des Beaux-Arts, Brussels, Belgium

"Video As Attitude," University Art Museum, University of New Mexico, Albuquerque, New Mexico

"The Second Link: Viewpoints on Video in the Eighties," Walter Philips Gallery, Banff, Alberta, Canada

"1983 Biennial Exhibition," Whitney Museum of American Art, New York, New York

1982

"The Sydney Biennale," Sydney, Australia

"Gary Hill: Equal Time." Long Beach Museum of Art, Long Beach, California

1981

"Projects Video XXXV," Museum of Modern Art, New York, New York

"New York Video," Stadtische Galerie im Lenbachhaus, Munich, Germany

1979

"Projects Video XXVII," Museum of Modern Art, New York, New York

"Video Revue," Everson Museum of Art, Syracuse, New York

"Beau Fleuve," Media Study, Buffalo, New York (travelled to: The Center for Media Art, American Center in Paris, France; L'espace lyonnais d'action culturelle, Lyon, France; Musée Cantini, Marseille, France)

1977

"New Work in Abstract Video Imagery," Everson Museum of Art, Syracuse, New York

1975

"Projects Video VI," Museum of Modern Art, New York, New York

"Annual Avant-Garde Festival of New York," New York, New York

1974

"Artists from Upstate New York," 55 Mercer Gallery, New York, New York

SELECTED PERFORMANCES

1997

"Splayed Mind Out" (work-in-progress) Gary Hill and Meg Stuart at the Kaaitheater, Brussels, April 23-26

1996

"Mysterious Object" Gary Hill, George Quasha and Charles Stein with Chie Hasegawa and Susan Quasha at the Rhinebeck Performing Arts Center

1993

Gary Hill, George Quasha, Charles Stein and Joan Jonas (on the ocassion of the opening of "Sites Re-cited" at the Long beach Museum of Art)

"Madness of the Day" Gary Hill with George Quasha and Charles Stein for

"Gary Hill: Day Seminar," on November 7, 1993 at the University of Oxford in Oxford, England in conjunction with the exhibition entitled *Gary Hill: In Light of the Other*

1988

"Soundings" Video Wochen, Basel, Switzerland

1978

"Sums & Differences", Arnolfini Arts Center, Rhinebeck, New York

1972

"Electronic Music: Improvisations," (performance with Jean-Yves Labat), Woodstock Artists' Association, Woodstock, New York

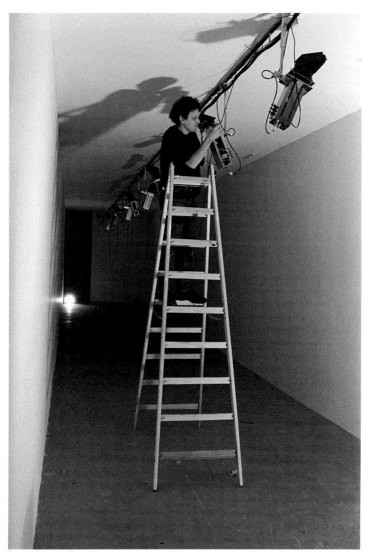

Gary Hill installing TALL SHIPS

Primarily Speaking, 1981-83 (New York: Whitney Museum of American Art, 1983).

"Happenstance (explaining it to death)." *Video d'Artistes* (Geneva: Bel Vedere, 1986).

"URA ARU: The Acoustic Palindrome." *Video Guide* 7 (No. 4, 1986).

"Processual Video" (videotape transcription). *2nd International Week of Video* (Geneva: St. Gervais, 1987).

"Primarily Speaking." *Video Communications*, No. 48 (Paris: 1988).

"And if the Right Hand Did not Know What the Left Hand is Doing." *Illuminating Video*, eds. Doug Hall and Sally Jo Fifer (New York: Aperture Press in association with the Bay Area Video Coalition, 1990), pp. 91-99.

"*BEACON* (Two Versions of the Imaginary), "essay from the exhibition catalogue, *ENERGIEEN* (Amsterdam: Stedelijk Museum, 1990). Reprinted in the catalogue, *Bienal de la Imagen en Movimiento '90* (Madrid: Museo Nacional Centro de Arte Reina Sofia, 1990).

"Site Re:cite" from "Unspeakable Images." *Camera Obscura* No. 24, (San Francisco: 1991).

"LEAVES." *Gary Hill—I Believe It Is an Image* (Tokyo: Watari Museum of Contemporary Art, 1992).

"Entre-vue." *Gary Hill* (Paris: Centre Georges Pompidou, 1992), pp. 8-13. Also available in Spanish with an English translation as "Entre-vista" in the exhibition catalogue of the same name (Valencia: IVAM, 1993), pp. 12-17; and in English with Dutch and German translations, as "Inter-view" in the exhibition catalogue of the same name (Amsterdam: Stedelijk Museum and Vienna: Kunsthalle, Wien, 1993), pp. 13-17.

"Entre 1 & 0." *Gary Hill* (Paris: Centre Georges Pompidou, 1992), pp. 74-76. Also available in Spanish with an English translation as "Entre 1 & 0" in the exhibition catalogue of the same name (Valencia: IVAM, 1993), pp. 78-80; and in English with Dutch and German translations, as "Between 1 & 0" in the exhibition catalogue of the same name (Amsterdam: Stedelijk Museum and Vienna: Kunsthalle, Wien, 1993), pp. 37-39.

Principal Books, Catalogues and Monographs

(arranged chronologically)

Quasha, George. "Notes on the Feedback Horizon." *Glass Onion* (Barrytown, N.Y.: Station Hill Press, 1980).

Devriendt, Christine. *L'Oeuvre Video de Gary Hill* (French and English). (Rennes: Université de Rennes II, 1990-91).

Gilbert, Christophe. *Maurice Blanchot/Gary Hill: d'une Ecriture l'Autre (et Son Double).* (Paris: DEA Université Paris-III, 1992).

Sarrazin, Stephen. *Chimaera Monographe No. 10 (Gary Hill).* (Montbéliard: Centre International de Création Vidéo Montbéliard, Belfort, 1992).

OTHERWORDSANDIMAGES: Video by Gary Hill (Danish and English). (Copenhagen: Video Gallerie/ Ny Carlsberg Glyptotek, 1990).

Lageira, Jacinto. "Sprachen Video." *Between Cinema and a Hard Place* (French). (Paris: OCO Espace d'Art Contemporain, 1991).

Gary Hill, Video Installations (Eindhoven: Stedelijk Van Abbemuseum, 1992).

Gary Hill—I Believe It Is an Image (Tokyo: Watari Museum of Contemporary Art, 1992).

Gary Hill: Sites Recited, 60 minute videeotape produced, directed and edited for the Long Beach Museum of Art by Carole Ann Klonarides, Media Arts Curator, with Joe Leonardi, General Manager of the LBMA Video Annex, in collaboration with Gary Hill, George Quasha, and Charles Stein (in performance and on-site dialogue), as a video catalogue for *Gary Hill: Sites Recited* at the Long Beach Museum of Art (Dec.3, 1993—Feb. 20, 1994).

Gary Hill (Seattle: Henry Art Gallery, 1994).

Gary Hill: Tall Ships, Clover (Stockholm: Riksutställningar, 1995).

Gary Hill: Imagining the Brain Closer than the Eyes. (Basel: Museum für Gegenwartskunst, 1995). Published in English and in German.

Quasha, George and Charles Stein. *Gary Hill: Hand Heard—Liminal Objects* (Paris and Barrytown, New York: Galerie des Archives and Station Hill Arts of Barrytown, Ltd., 1996).

Principal Texts

(arranged alphabetically)

Cooke, Lynne. "Gary Hill: 'Who am I but a figure of speech?'" *Parkett*, No. 34 (1992), pp. 16-27.

Cooke, Lynne. "Gary Hill: au-dela de Babel." *Gary Hill* (Paris: Centre Georges Pompidou, 1992), pp. 78-115. Also available in Spanish with an English translation as "Gary Hill: mas alla de Babel" in the exhibition catalogue of the same name (Valencia: IVAM, 1993), pp. 82-119; and in English with Dutch and German translations as "Gary Hill: Beyond Babel" in the exhibition catalogue of the same name (Amsterdam: Stedelijk Museum and Vienna: Kunsthalle, Wien), pp. 40-99.

Bellour, Raymond. "Le dernier homme en croix." *2nd Semaine International de Video* (Geneva: Bel Veder, Centre Génevois de Gravure Contemporaine, 1987). Also published in *Illuminating Video*, eds. Doug Hall, Sally Jo Fifer (New York: Aperture Press in association with the Bay Area Video Coalition, 1990), pp. 425-426, and in *OTHERWORDSANDIMAGES: Video by Gary Hill* (Danish and English). (Copenhagen: Video Gallerie/Ny Carlsberg Glyptotek, 1990), pp. 20-26.

Derrida, Jacques. "Videor." *Passages de l'Image* (French). (Paris: Musée National d'Art Moderne, Centre Georges Pompidou, 1990), pp. 158-161. Also available in English in the exhibition catalogue of the same name (Barcelona: Centre Cultural de la Fundacio Caixa de Pensions, 1991), pp. 174-179.

Diserens, Corinne. "Inasmuch As It Is Always Already Taking Place." *Gary Hill: In Light of the Other* (Oxford: The Museum of Modern Art Oxford and Liverpool: Tate Gallery Liverpool, 1993).

Duncan, Michael. "In Plato's Electronic Cave." *Art in America*, Vol 83, no. 6 (June 1995): 68-73.

Fargier, Jean-Paul. "Magie Blanche." *Gary Hill: DISTURBANCE (among the jars)*. (French and English.) (Villeneuve d'Ascq: Musée d'Art Moderne, 1988), unpaginated.

Furlong, Lucinda. "A Manner of Speaking: An Interview with Gary Hill." *Afterimage* 10 (March 1983), pp. 9-16.

Grout, Catherine. "Gary Hill—La condition humaine de la pensee." *Arte Factum*, No. 48 (June/July/August 1993), pp. 8-12.

Huici, Fernando. "Gary Hill: *Beacon*." *Bienal de la Imagen en Movimiento '90* (Madrid: Museo Nacional Centro de Arte Reina Sofia, 1990).

Kain, Jackie. "L'intime du mot: l'oevre video de Gary Hill." *2nd Semaine Internationale de Video* (Geneva: Bel Veder, Centre Génevois de Gravure Contemporaine, 1987).

Kandel, Susan. "Gary Hill, Museum of Contemporary Art," *ArtForum*, Vol. 33, no. 8 (April 1995): 86-7.

Kolpan, Steven. "Bateson: Through the Looking Glass." *Video and the Arts* (Winter 1986), pp. 20, 22, 35, 56. also: *1986 Saw Gallery International Festival of Video Art* (Ottawa, Ontario: Saw Gallery, 1986).

Lageira, Jacinto. "L'image du monde dans le corps du texte." *Gary Hill* (Paris: Centre Georges Pompidou, 1992), pp. 34-71. Also available in Spanish with an English translation as "La imagen del mundo en el cuerpo del texto" in the exhibition catalogue of the same name (Valencia: IVAM, 1993), pp. 38-75.

Lageira, Jacinto. "Une Verbalisation du Regard." *Parachute*, No. 62 (April/May/June 1991), pp. 4-11.

Lestocart, Louis-José. "Gary Hill: Surfer sur le medium / Surfing the Medium," *artpress* (February 1996): pp. 20-27.

Massardier, Hippolyte. "Du bec et des ongles." *Gary Hill* (Paris: Centre Georges Pompidou, 1992), pp. 118-129. Also available in Spanish with an English translation as "Con unas y dientes" in the exhibition catalogue of the same name (Valencia: IVAM, 1993), pp. 120-133.

Mayer, Marc. *Being and Time: The Emergence of Video Projection* (Buffalo: Albright-Knox Art Gallery, 1996).

Mittenthal, Robert. "Standing Still On the Lip of Being: Gary Hill's 'Learning Curve'." *Gary Hill: In Light of the Other* (Oxford: The Museum of Modern Art Oxford and Liverpool: Tate Gallery Liverpool, 1993).

Mittenthal, Robert. "Reading the Unknown: Reaching Gary Hill's *And Sat Down Beside Her*" in *Gary Hill* (Paris: Galerie des Archives, 1990).

Quasha, George (with Charles Stein). "Tall Acts of Seeing." *Gary Hill*, in English with Dutch and German translations, (Amsterdam: Stedelijk Museum and Vienna: Kunsthalle, Wien, 1993), pp. 99-109.

Quasha, George. "Disturbing Unnarrative of the Perplexed Parapraxis (A Twin Text for DISTURBANCE)." *Gary Hill: DISTURBANCE (among the jars)* (French and English). (Villeneuve d'Ascq: Musée d'Art Moderne, 1988), unpaginated.

Quasha, George (with Charles Stein). "A Transpective View." *Spinning the Spur of the Moment (A Retrospective in Three Laserdisc Volumes)*, accompanying catalogue (New York: The Voyager Company, 1994), pp. 4-7.

Quasha, George and Charles Stein. "Cut to the Radical of Orientation: TWIN NOTES ON being in touch in Gary Hill's [Videosomatic] Installation, CUT PIPE." *Public 13: Touch in Contemporary Art* (Toronto: Public Access, 1996), pp. 65-83

Sarrazin, Stephen. "Channeled Silence (Quiet, Something 'is' Thinking)" *Gary Hill—I Believe It Is an Image* (Tokyo: Watari Museum of Contemporary Art, 1992).

Van Weelden, Willem. "Primarily Spoken." *Gary Hill,* in English with Dutch and German translations, (Amsterdam: Stedelijk Museum and Vienna: Kunsthalle, Wien, 1993), pp. 21-35.

Van Assche, Christine. "Interview with Gary Hill." *Galeries Magazine* (December 1990/January 1991), pp. 77, 140-141.

Young, Lisa Jaye. "Electronic Verses: Reading the Body vs. Touching the Text," *Performing Arts Journal 52* (Vol. 18, No. 1, January 1996), pp. 36-43

tall ships exhibitions

FORTHCOMING EXHIBITIONS

1997-1998
Henry Art Gallery,
Seattle, Washington
April 13 - June 29, 1997

"Being and Time: The
Emergence of Video Projec-
tion" (traveling group exhi-
bition organized by the
Albright Knox Art Gallery)
Portland Art Museum,
Portland, Oregon
May 24 - July 27, 1997
Contemporary Arts Museum,
Houston, Texas
August 8 - October 12, 1997
Site Santa Fe, Santa Fe,
New Mexico
September - January 1998

Magneto, Centro Cultural
Banco do Brasil,
Rio de Janeiro
(traveling solo exhibition)
July 2 - September 1998
Museum of Modern Art, São
Paulo, Brazil
October - December 1998

SOLO EXHIBITIONS

1995
"Gary Hill," Moderna Museet,
Stockholm, Sweden (Scandi-
navian touring exhibition or-
ganized by Riksutställningar,
Stockholm, Sweden)
February 2 - April 17

"Gary Hill," Museet for
Samtidskunst, Oslo, Norway
(Scandinavian touring exhi-
bition organized by
Riksutställningar,
Stockholm, Sweden)
April 26 - May 21

"Gary Hill," Kunstforeningen,
Copenhagen, Denmark
(Scandinavian touring exhi-
bition organized by
Riksutställningar,
Stockholm, Sweden)
May 27 - June 18

"Gary Hill," Helsingfors
Konsthall, Helsinki, Finland
(Scandinavian touring exhi-
bition organized by
Riksutställningar,
Stockholm, Sweden)
June 24 - July 31

"Gary Hill," Bildmuseet,
Urneå, Sweden (Scandina-
vian touring exhibition orga-
nized by Riksutställningar,
Stockholm, Sweden)
September 3 - October 15

"Gary Hill," Jönköpings Läns
Museum, Jönköping, Swe-
den (Scandinavian touring
exhibition organized by
Riksutställningar,
Stockholm, Sweden)
October 22 - November 15

"Gary Hill," Göteborgs
Konstmuseum, Göteborg,
Sweden
November 15 - January 14

1994
"Gary Hill," Musee d'Art
Contemporain, Lyon, France
May 26 - September 19

"Gary Hill," Stedelijk
Museum, Amsterdam,
The Netherlands

(traveling exhibition organized by the Centre Georges Pompidou)
August 27 - October 10

"Gary Hill: In Light of the Other," Museum of Modern Art, Oxford, England (installations)
November 7 - January 9, 1994

Selected Group Exhibitions

1997

"Being and Time: The Emergence of Video Projection," Cranbrook Art Museum, Bloomfield Hills, Michigan (traveling exhibition organized by the Albright Knox Art Gallery)
January 24 - March 29

1996

"Being and Time: The Emergence of Video Projection," Albright-Knox Art Gallery, Buffalo, New York (traveling exhibition organized by the Albright Knox Art Gallery)
September 21 - December 1

1994

"Múltiplas Dimensões," Centro Cultural de Belém, Lisbon, Portugal
June 7 - July 31

"Facts and Figures," Lannan Foundation, Los Angeles, California
October 22 - February 26

1993

"Biennial Exhibition," Whitney Museum of American Art, New York, New York
March - June

"Eadweard Muybridge, Bill Viola, Giulio Paolini, Gary Hill, James Coleman," Ydessa Hendeles Art Foundation, Toronto, Ontario, Canada
May 15 - Summer

1992

"Documenta IX," Museum Fridericianum, Kassel, Germany
June 13 - September 20

About the Authors

GEORGE QUASHA is the author of several published books of poetry including *Somapoetics, Giving the Lily Back Her Hands,* and the forthcoming *In No Time*; has edited several poetry anthologies including *America a Prophecy* and *Open Poetry*; and has been co-publisher/editor of Station Hill Press in Barrytown, New York since 1978. He is the recipient of a National Endowment for the Arts Fellowship in Poetry. He co-founded Open Studio, Ltd. and the Arnolfini Arts Center in Rhinebeck, New York in 1978. His ongoing collaborations with Gary Hill, begun in the late 1970s, include sound poetry performance (e.g., *Tale Enclosure,* a Gary Hill single-channel video), text and on-site direction for the installation *Disturbance (among the jars)* at the Centre Georges Pompidou in Paris, various kinds of writing and live performances, the latter extending his more than twenty years of performance and "dialogical" work with Charles Stein. George Quasha's work as artist (video, installation, performance) has been included in museum shows at The Center for Curatorial Studies in Annandale-on-Hudson, College Art Gallery at SUNY New Paltz, and the Blum Art Center in Annandale-on-Hudson, and, in a collaboration with Gary Hill and Charles Stein, at the Long Beach Museum of Art, California, The Museum of Modern Art, Oxford, England, etc. His collaborative writing related to Gary Hill's work has appeared in art catalogues of the Stedelijk Museum of Amsterdam, the Kunsthalle of Vienna, the Barbara Gladstone Gallery of New York, Public Access of Toronto, the Voyager Laserdisc Gary Hill, the Musée d'Art Moderne d'Ascq, etc. He has taught at SUNY Stony Brook, NYU, The New School for Social Research, Bard College, and The Naropa Institute.

◆

CHARLES STEIN is the author of ten books of poetry, many of which include his photographs. The most recent book is *The Hat Rack Tree* (1994). He is also the author of a critical study (including his photos) of the poet Charles Olson, *The Secret of the Black Chrysanthemum*, as well as other essays on philosophical and literary subjects. He plays Gregory Bateson in Gary Hill's *Why Do Things Get in a Muddle?* and is one of the two performers (with George Quasha) in Gary Hill's *Tale Enclosure*. He has worked with George Quasha for many years in the production of "dialogical" critical texts. He holds a Ph.D. in literature and currently resides in Barrytown where he is Senior Editor at Station Hill Press. His photography has appeared in solo exhibitions at The College Art Gallery of SUNY New Paltz, The University of Connecticut Library in Storrs, The Arnolfini Arts Center in Rhinebeck, New York, the Robert Louis Stevenson School in New York, New York, and on the covers of numerous books of poetry and fiction. In collaboration with Gary Hill and George Quasha, he has performed at the Long Beach Museum of Art, California, The Museum of Modern Art, Oxford, England, The Rhinebeck Performing Arts Center, etc. His collaborative writing related to Gary Hill's work has appeared in art catalogues of the Stedelijk Museum of Amsterdam, the Kunsthalle of Vienna, the Barbara Gladstone Gallery of New York, Public Access of Toronto, the Voyager Laserdisc Gary Hill, etc. He has taught in Bard College's "Music Program Zero" and at SUNY Albany and The Naropa Institute.

Acknowledgements

The artist wishes to express his very special thanks to Jan Hoet, Director of Documenta IX, for commissioning and first exhibiting *Tall Ships*, and to Dorine Mignot of the Stedelijk Musuem for making it possible to show the long version *of Tall Ships,* and to extend his gratitude to the following for their support and assistance: The Lannan Foundation, Ydessa Hendeles, Chrissie Iles, Lewis Biggs. George Quasha, Susan Quasha, Charles Stein.

The authors and publishers wish to thank Dorine Mignot who commissioned the first version of "Tall Acts of Seeing" for the Stedelijk Museum catalogue, *Gary Hill,* and for permission to reprint it here.

Video Production Credits: Special hardware/software design: Dave Jones; special thanks to the participants in *Tall Ships* listed in Note 1 to "Tall Acts of Seeing"; lighting: Rex Barker; production assistance: Mark McLoughlin, Paul Kranko

Photo Credits: All photos unless otherwise noted, courtesy of Donald Young and Gary Hill. Cover photo, also on opening page, by: Robert Keziere used by permission of Ydessa Hendeles. Title page photo by Dirk Bleicker.

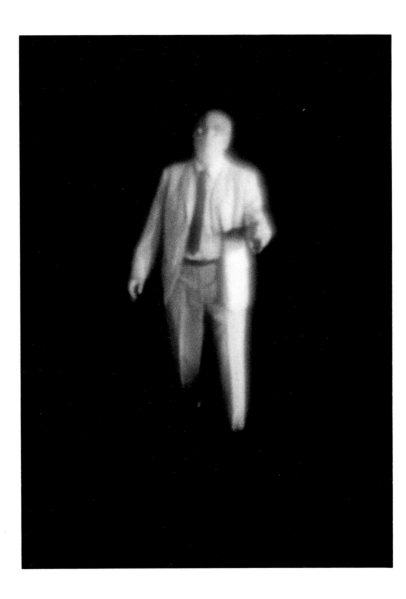